A LEGEND OF PARADISE

A legend of paradise

ST. MARTIN'S PRESS · NEW YORK

Lies Wiegman

Margareta Strömstedt

Photographs © by Lies Wiegman
Text © by Margareta Strömstedt.
All rights reserved.
For information, write: St. Martin's Press, Inc.,
175 Fifth Ave., New York, N.Y. 10010
Printed in Great Britain
Library of Congress Catalog Card
Number: 71-158329
First published in the
United States of America in 1971

AFFILIATED PUBLISHERS
Macmillan & Company, Limited, London—
also at Bombay, Calcutta, Madras
and Melbourne—
The Macmillan Company of Canada, Limited, Toronto.

PUBLISHERS' NOTE

*"All this is yours," I told the boy. "The
earth, the trees and every creature."*
 *"But who will play with me?" he cried.
Then I created the girl.*

This book is many things. It is a new legend, a dream
story in words and pictures. It echoes all myths of
creation, yet it is not a parable of good and evil, but a
fable of hope. It is a book about and for children. It is
also perhaps the most mature love story you will ever
read.

Last night I dreamt that I created the world.
I was omnipotent as I moved above the wide waters.

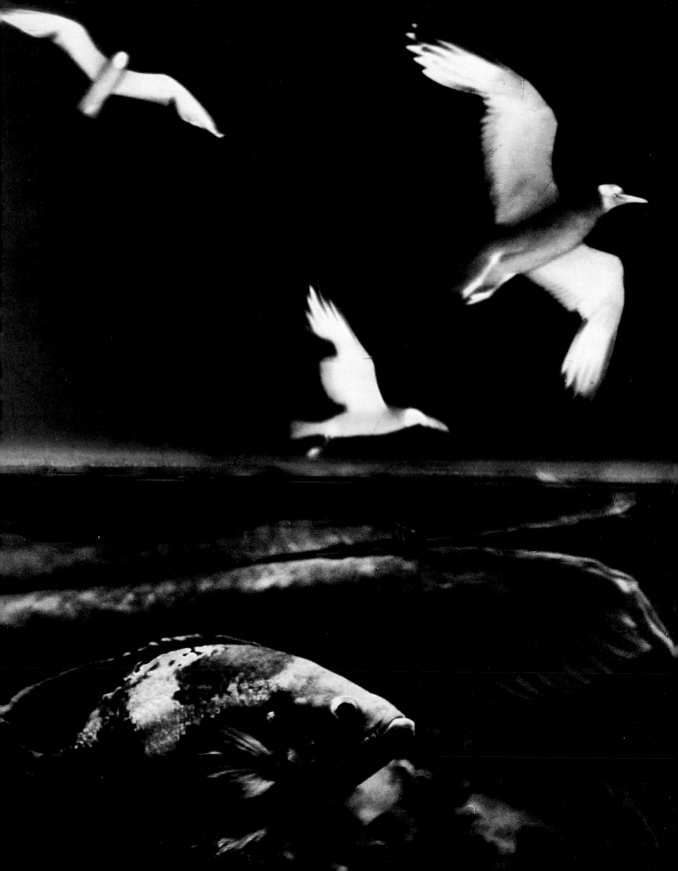

"Come, birds!" I called. "Fly!"
"Come, fishes," I whispered, "swim in my many seas."

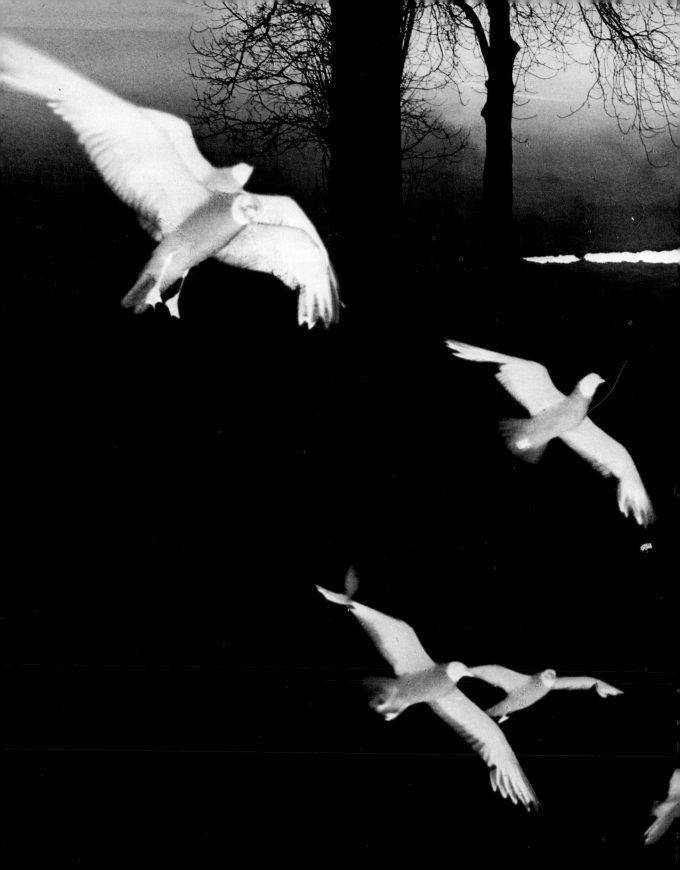

Out of nowhere
white birds came flocking.
They flew towards the light.
I shivered at the sight of so
much radiance.

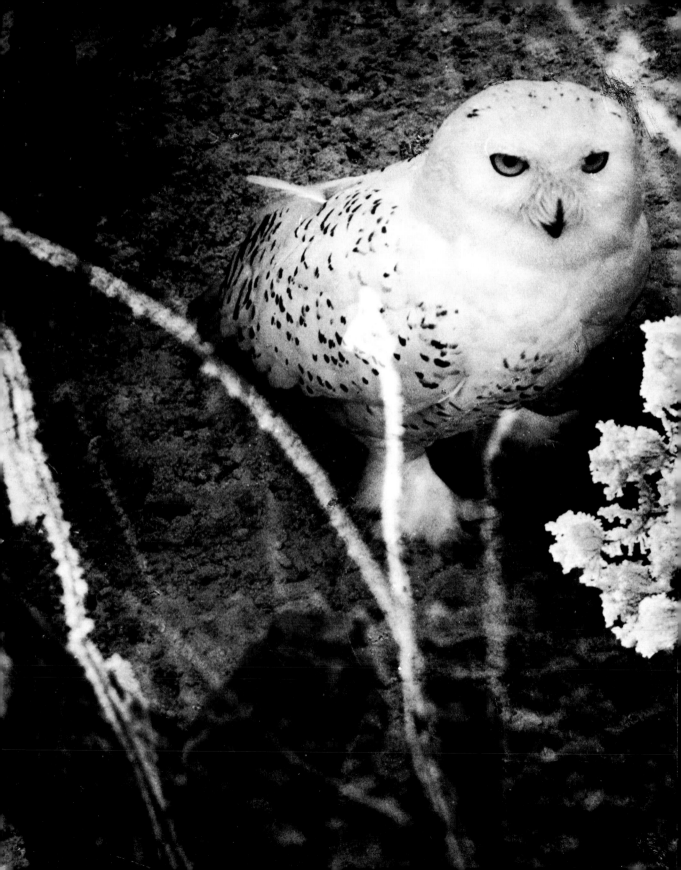

Suddenly I saw among the trees
a white owl
which I had created with my
call.
Wonderingly it stared at me.

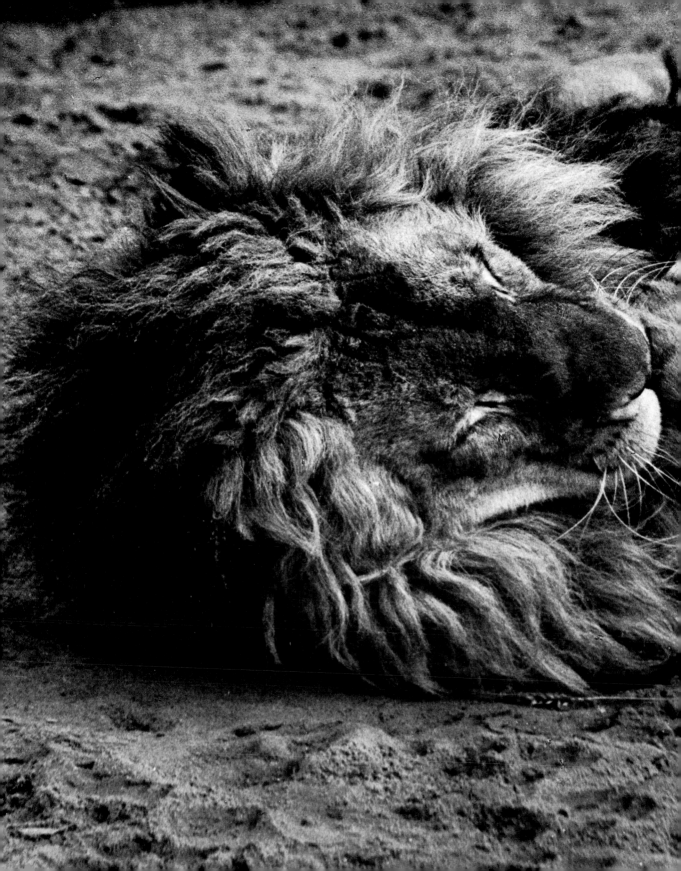

The lion did not yet know his
strength.
I breathed upon him.
He rose up and roared,
shaking the earth with his
noise.

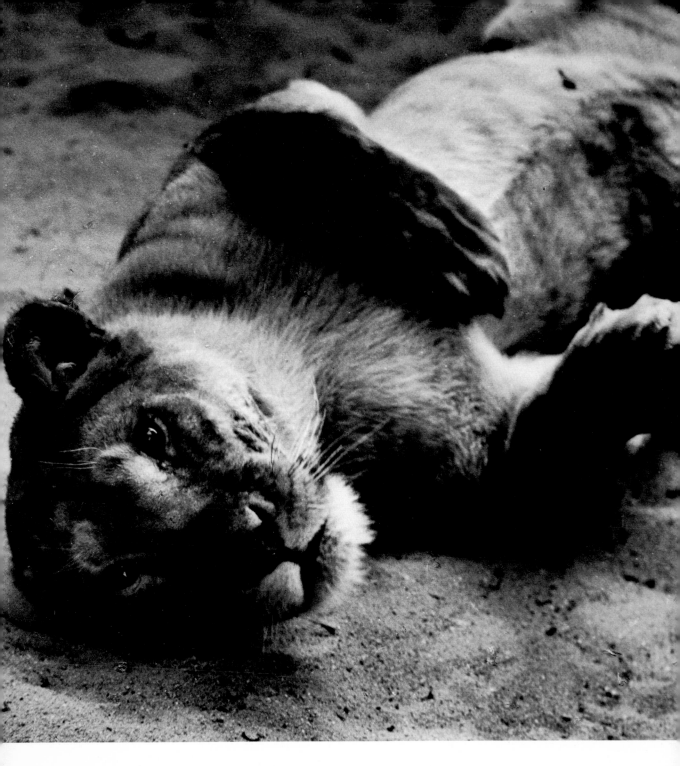

The lioness opened her eyes.

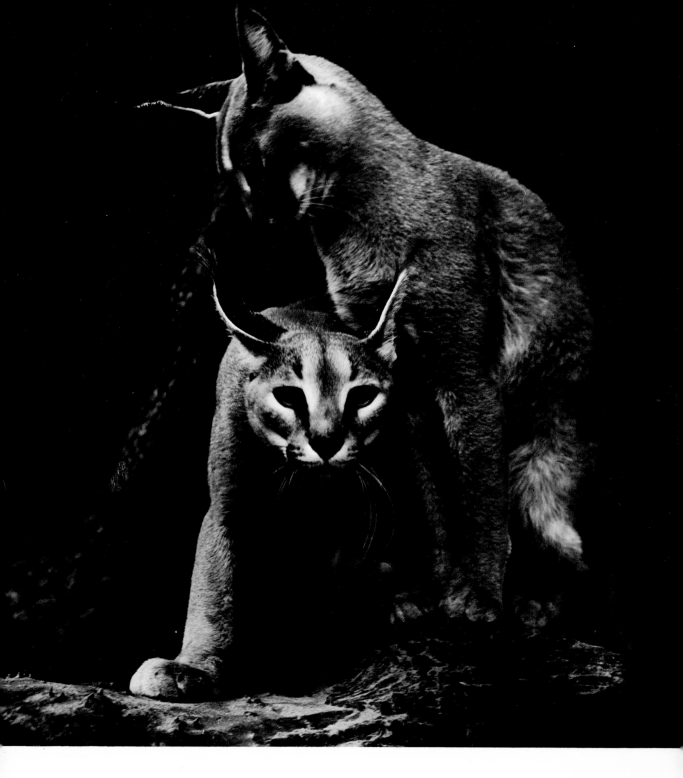

On soft paws the lynxes came slinking out of the darkness.

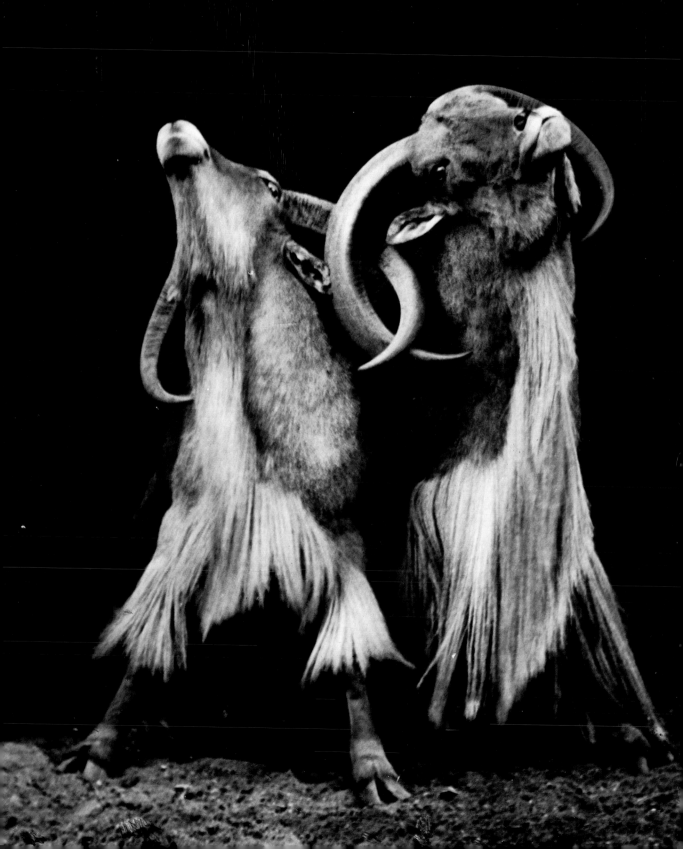

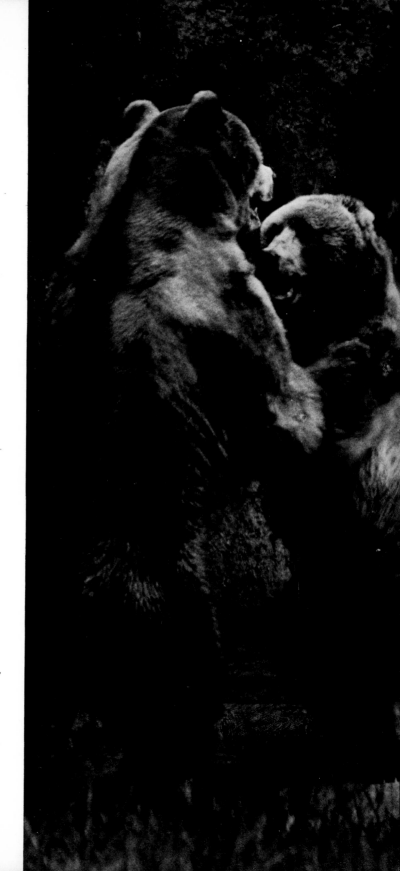

I made the he-goats with their curved horns.
I gave the bears their soft, shaggy coats.
They danced in delight when they first found each other.

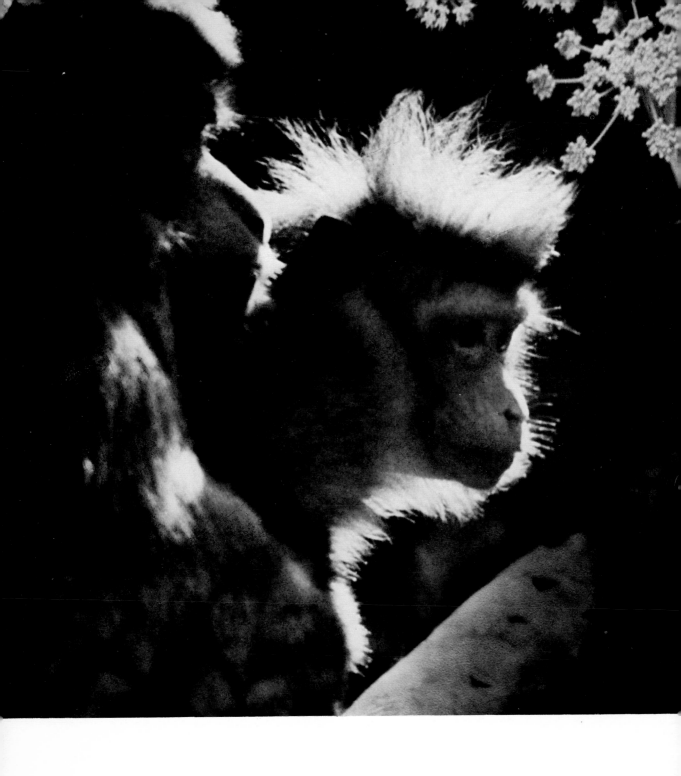

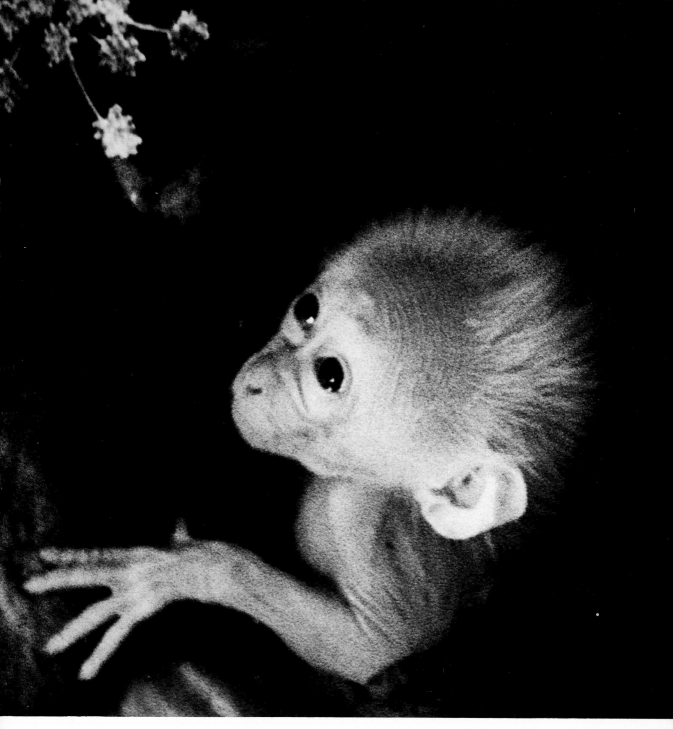

A tiny monkey appeared and gazed at me.
"Who am I? What is this place?" he asked.
"You are a little monkey in this paradise which I
have made: no more than that, no less," I answered.

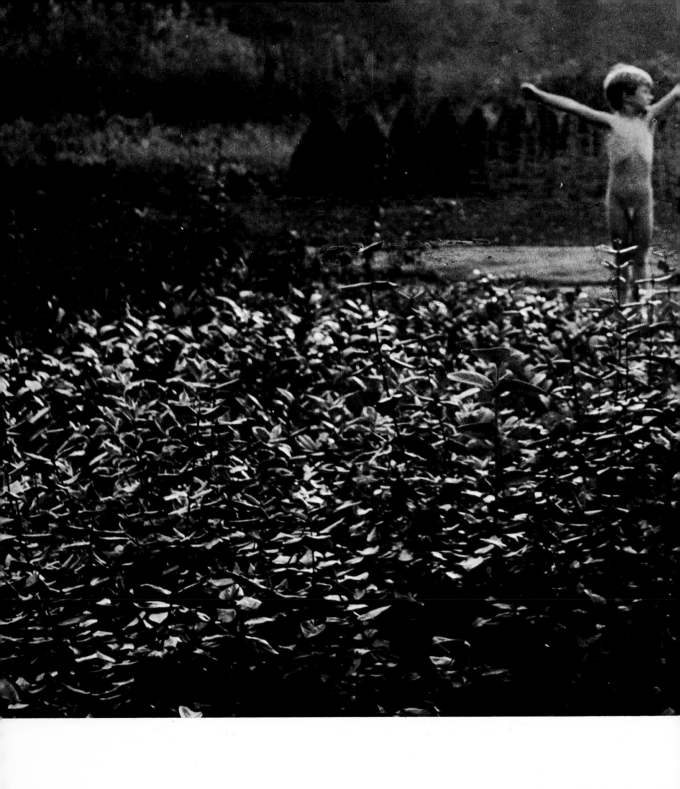

When the sun rose on my paradise, I created the boy. He breathed; he stretched his arms towards the light.

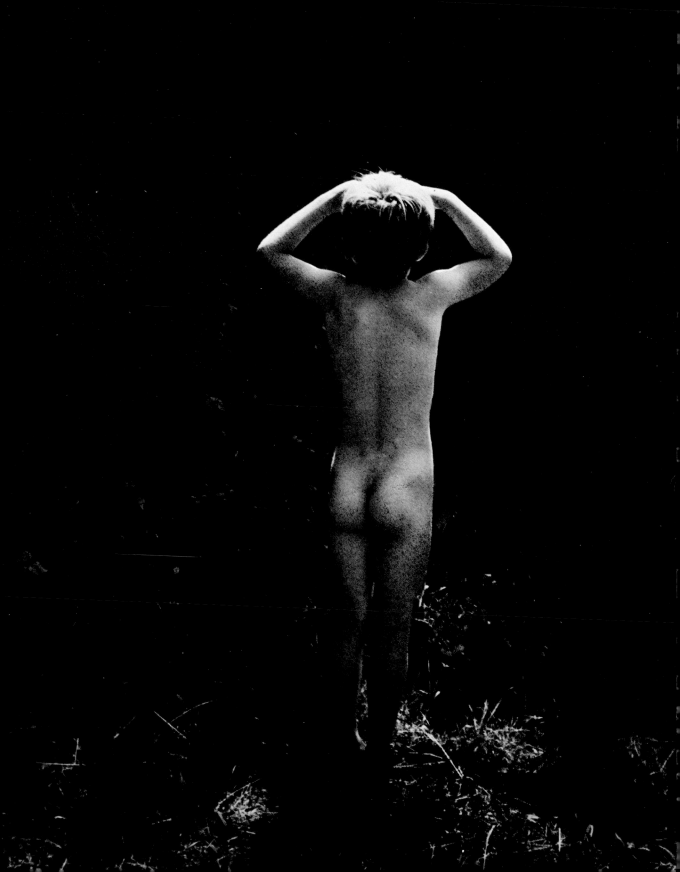

He looked into the distance, as though he expected something else.

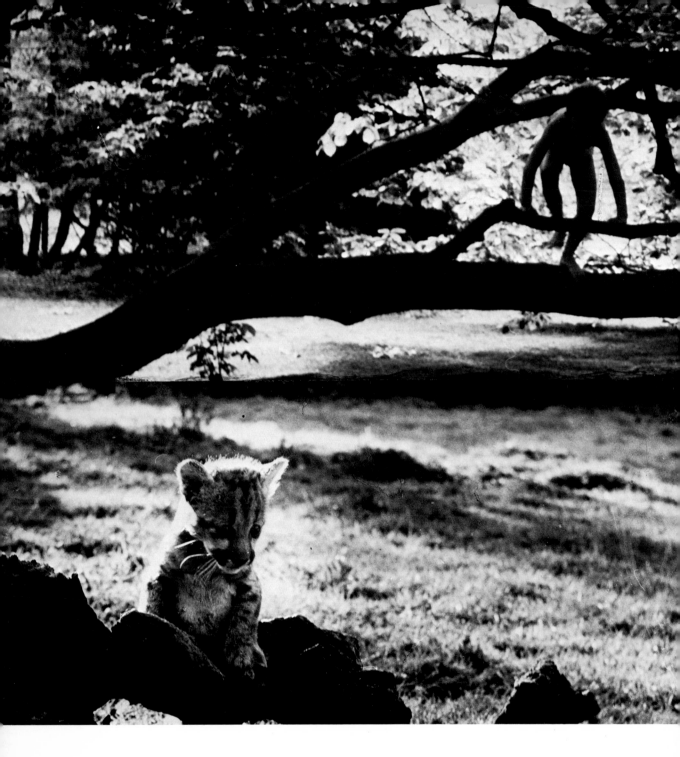

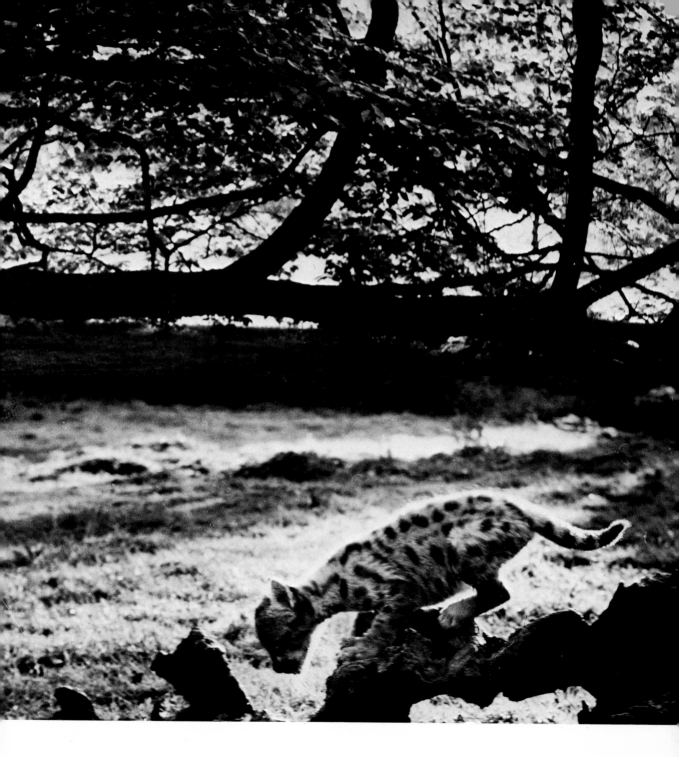

"All this is yours," I told the boy. "The earth, the trees, and every creature."
"But who will play with me?" he cried.

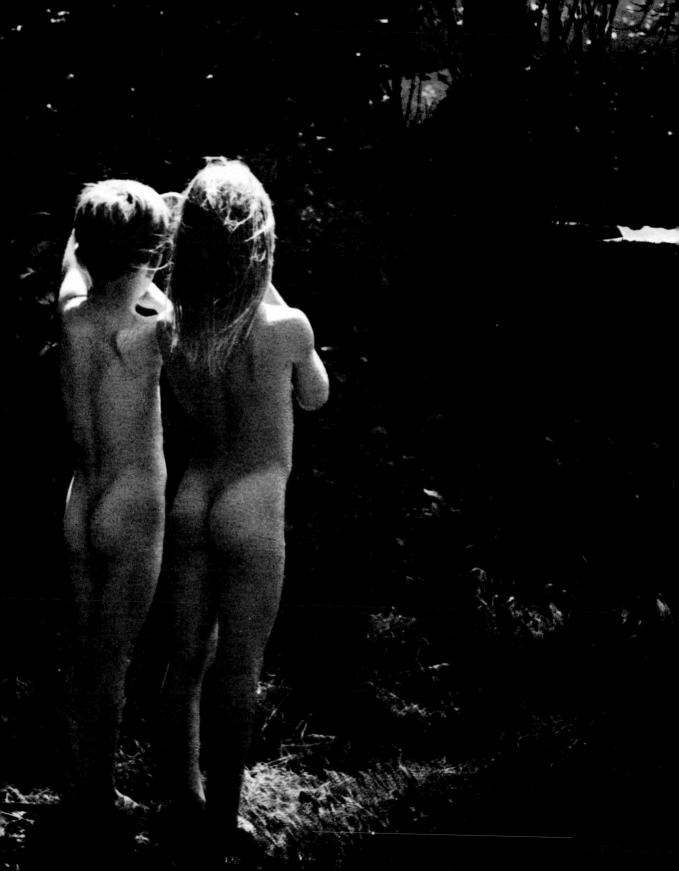

Then I created the girl.
She appeared and stood beside
the boy.
"This is Paradise," the boy
told her.
"We shall live here."

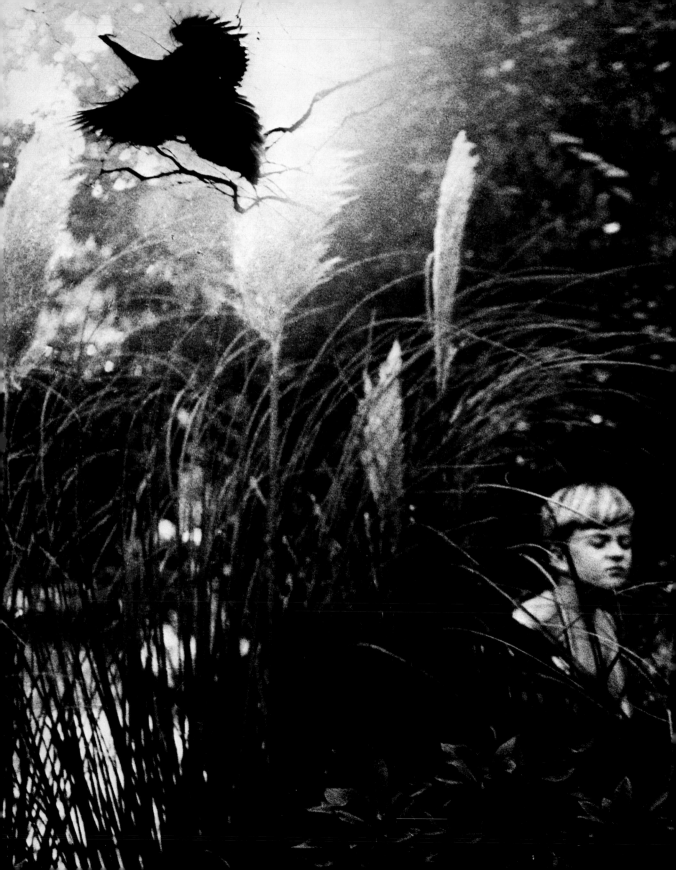

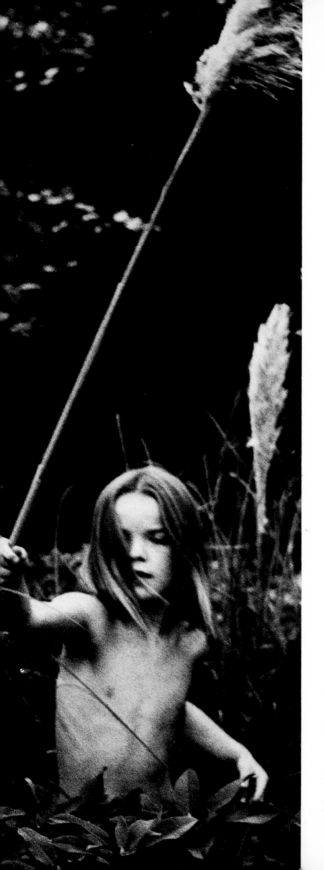

Together they pushed their
way through the undergrowth.
"We shall discover all the
secrets of Paradise," the
girl said.

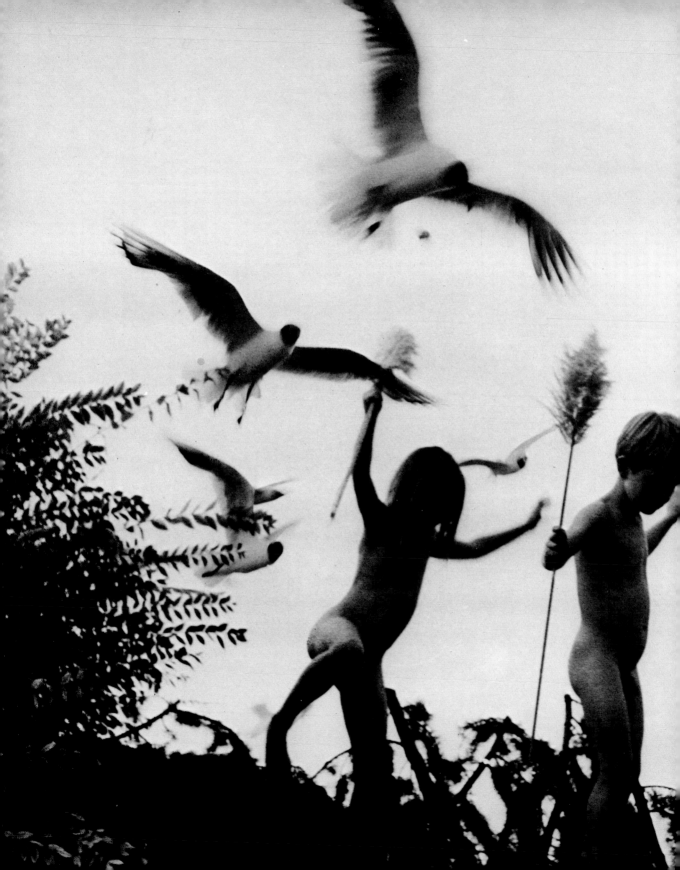

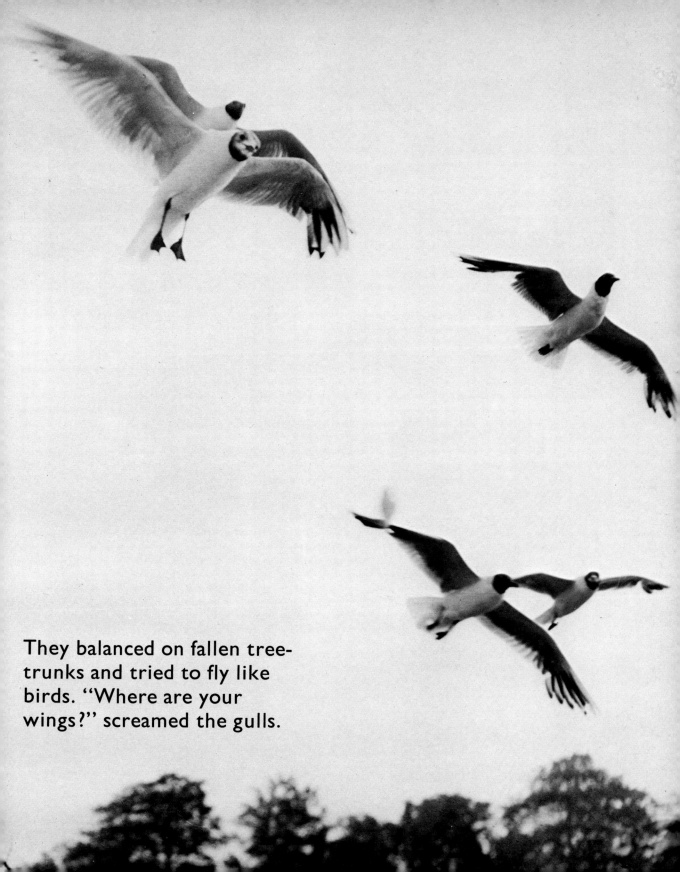

They balanced on fallen tree-
trunks and tried to fly like
birds. "Where are your
wings?" screamed the gulls.

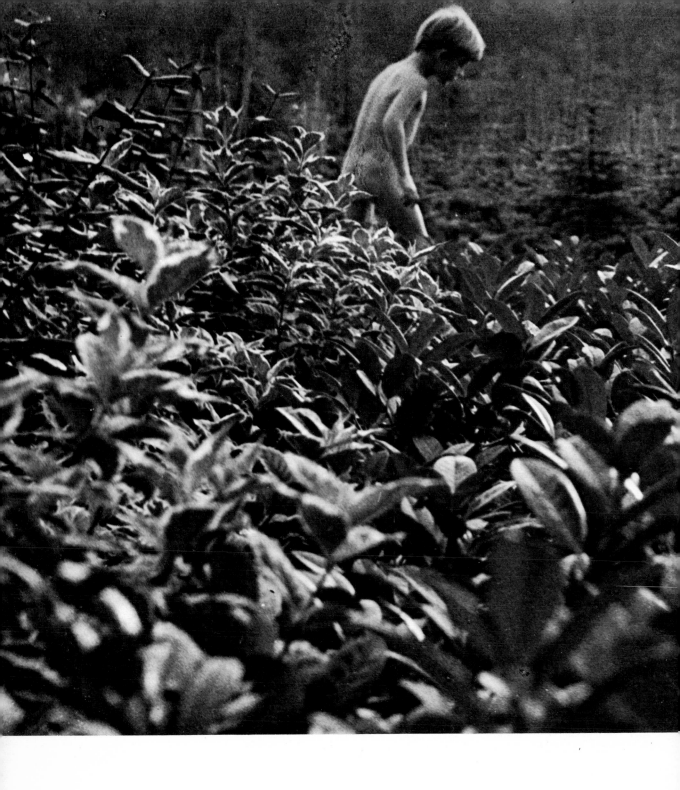

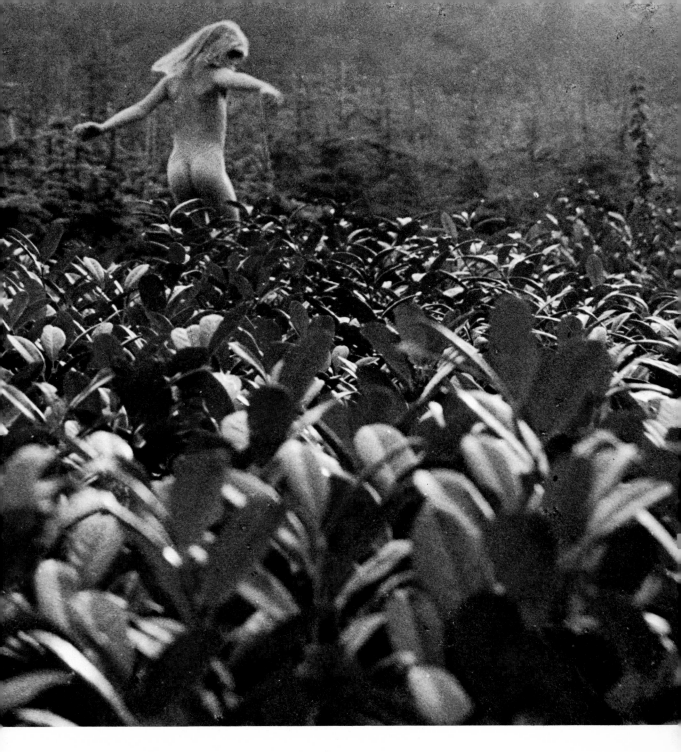

They picked their way over the ground.
It was hard underfoot. I covered it with green moss.
"How soft it is!" the girl exclaimed.

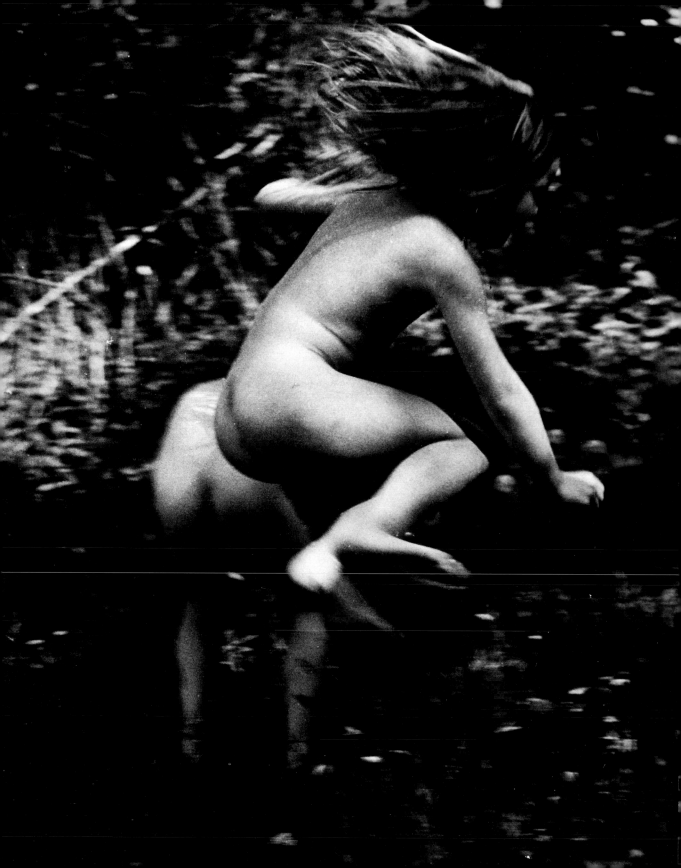

"Watch!" she cried. "I can fly on the wind!"
She sprang into the air, and I held her safe
in my invisible hands.

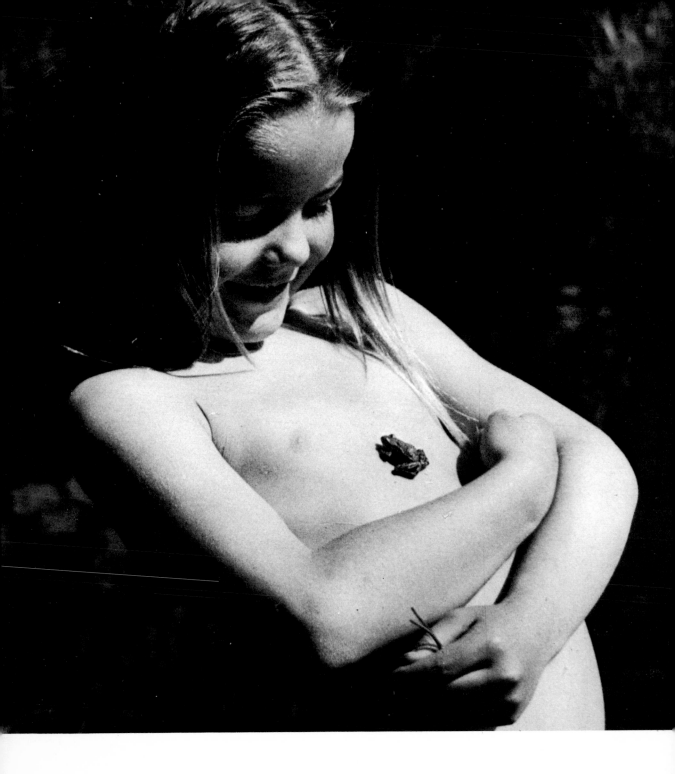

The girl smiled. "Look at this little green frog.
It has no fear of me."

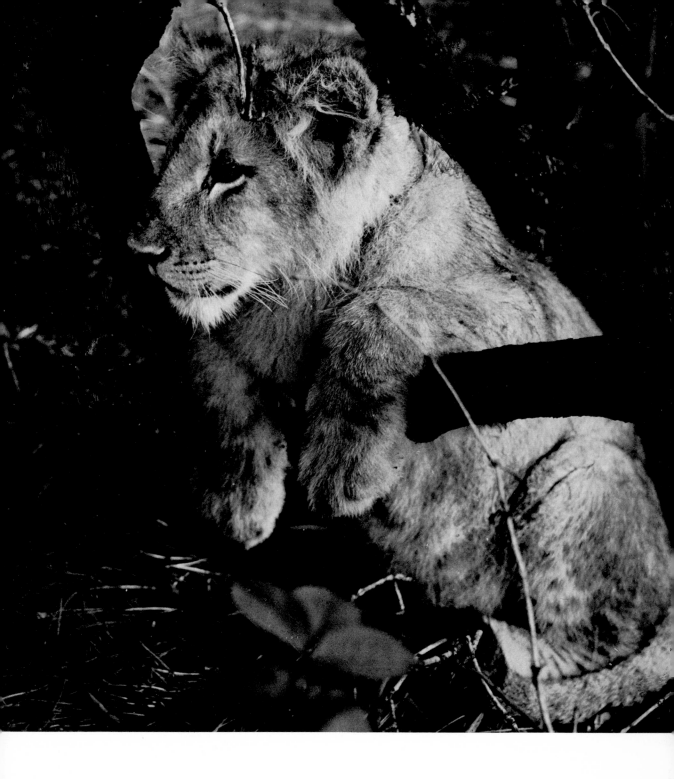

Then the lioness growled.
The frog leapt away into the thickets.

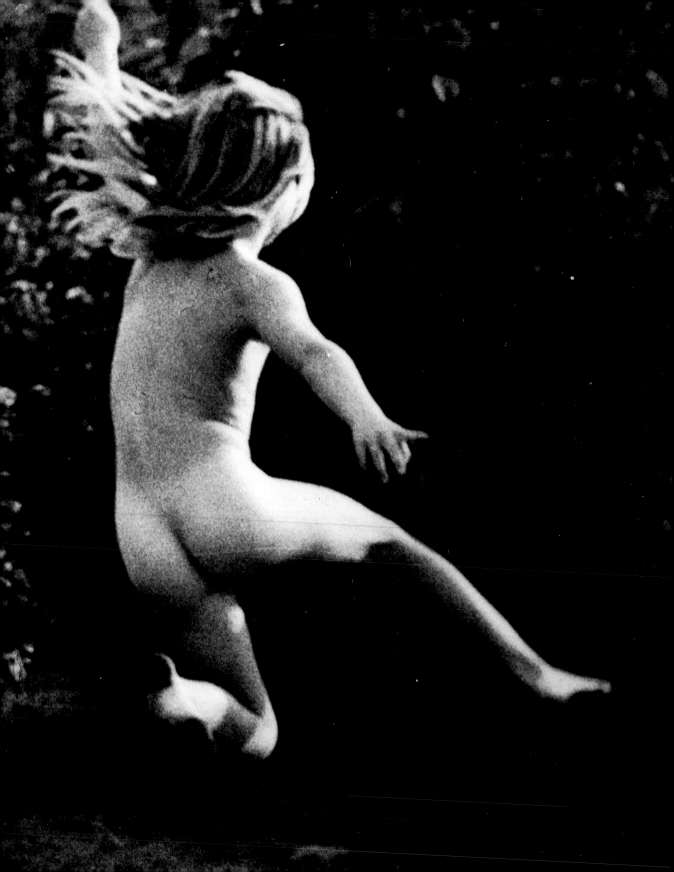

The girl bounded after it.
"Come back, little frog!"
she cried.

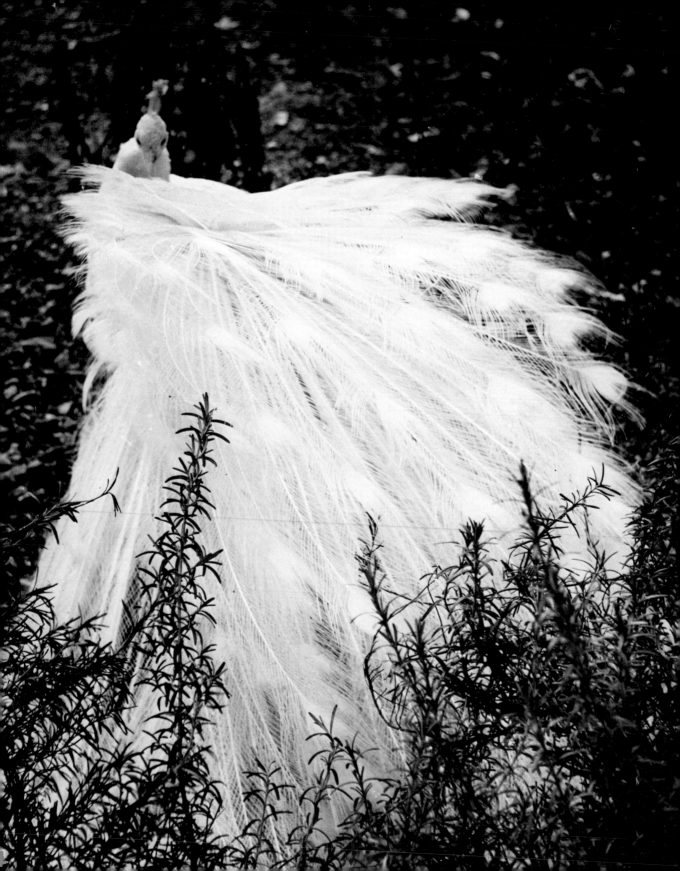

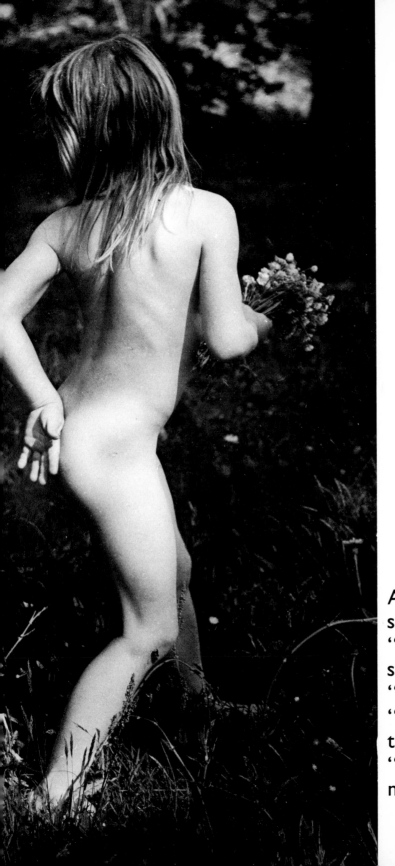

All at once the girl realized
she was alone.
"Where has the boy gone?"
she asked the peacock.
"Have you seen him?"
"I have just been created,"
the peacock replied.
"I am too busy admiring
myself to notice anything else."

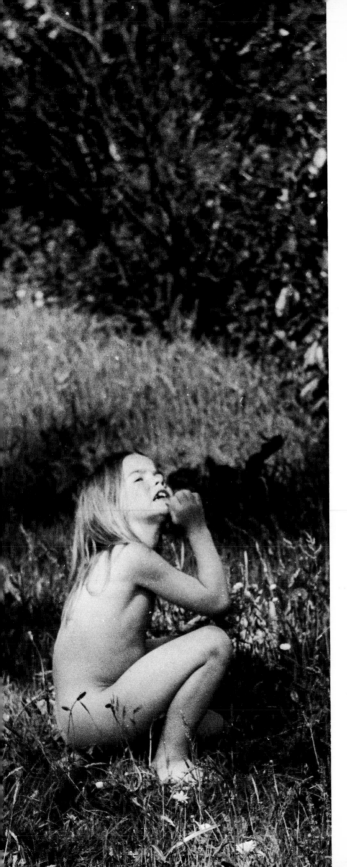

The girl sat on the ground.
She closed her eyes and
wished that the boy would
return.

I brought the boy back to her.
As they explored my paradise,
they found trees heavy with
white blossom and luscious
fruits.

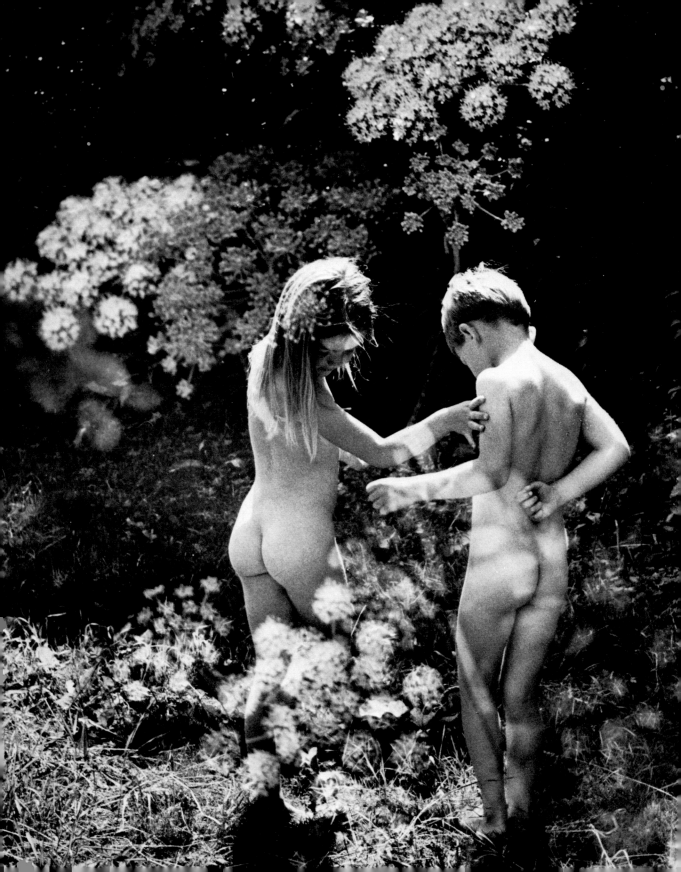

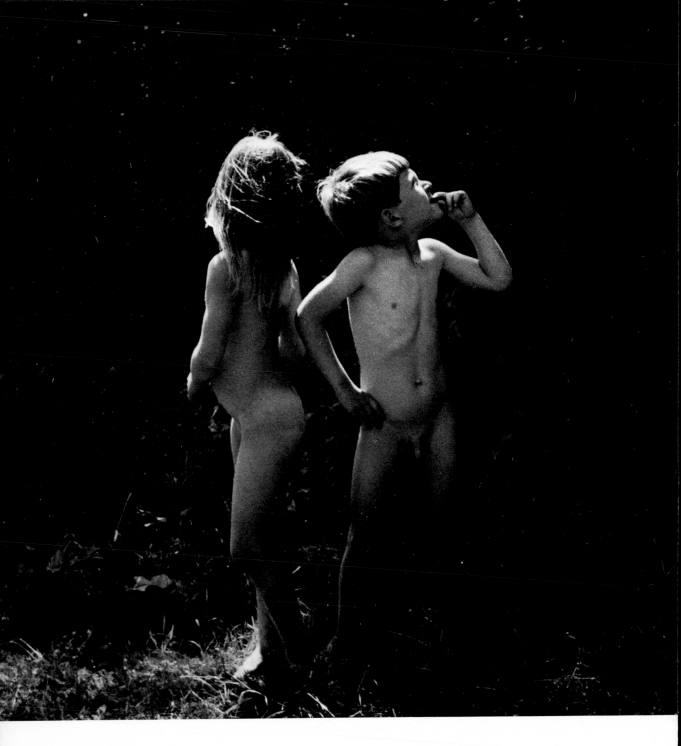

Then they came to a tree laden with shining apples.
"Do not eat the apples," I whispered to them.
"There is poison in them. If you eat them,
the spell of Paradise will be broken."

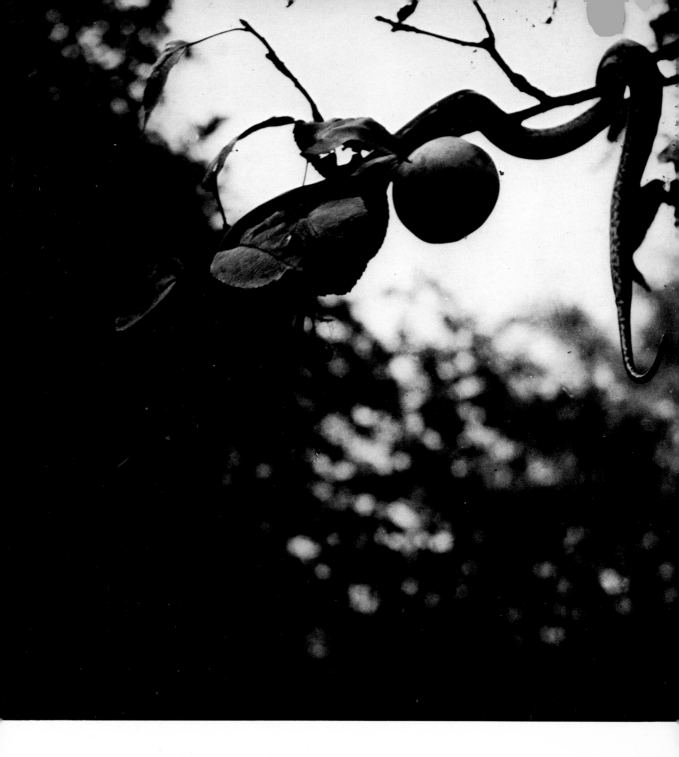

A cunning serpent hung on a branch.
"Eat, eat the apples," he hissed. "They
taste so good . . . so good."

The girl hesitated – but only for a second.
"They are so beautiful, these shining apples," she
said. "I must try one. If it tastes bad, we can
spit it out."

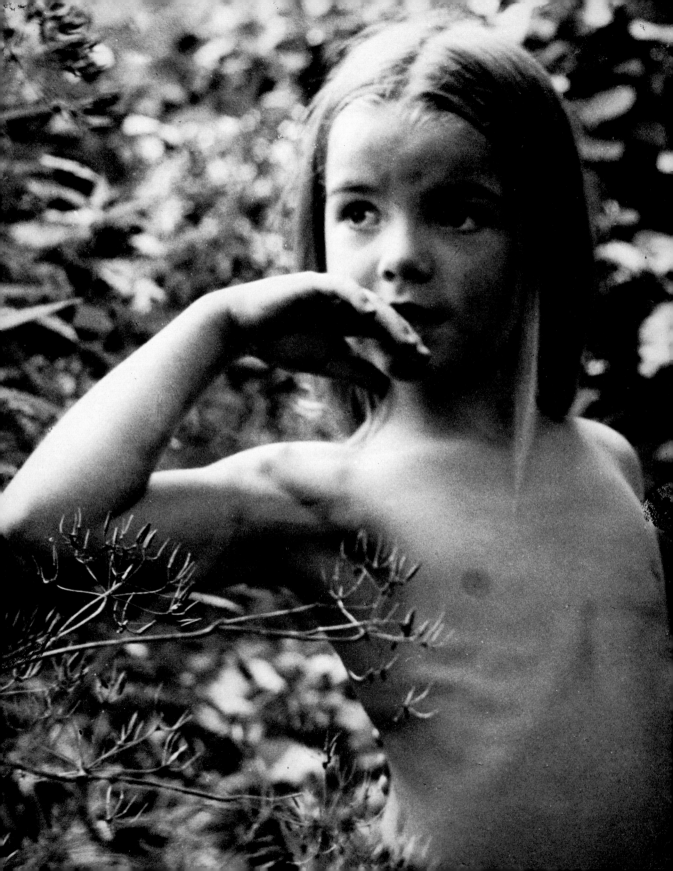

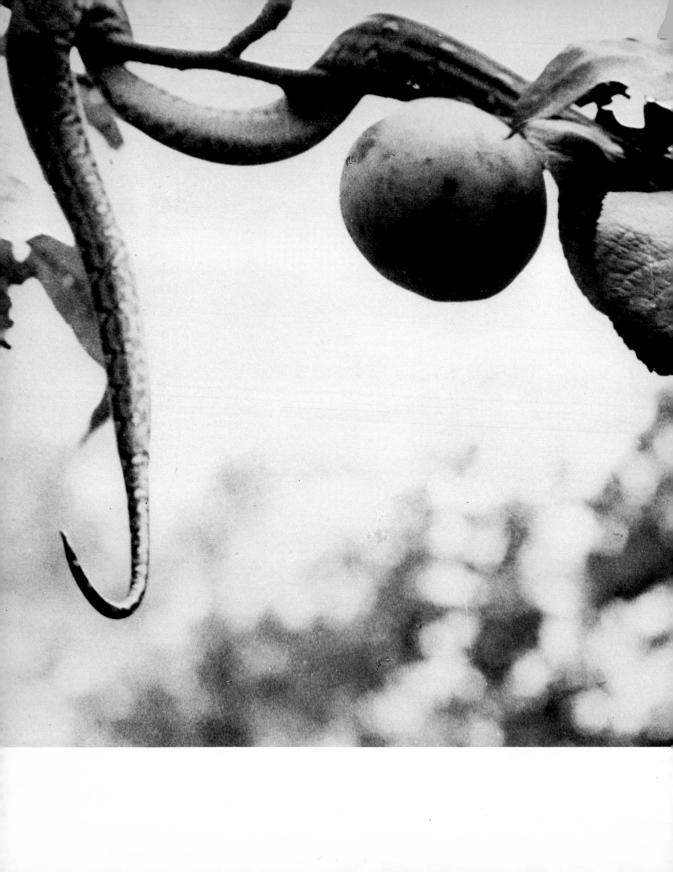

And the girl stretched out her hand to pluck
the poisoned apple.

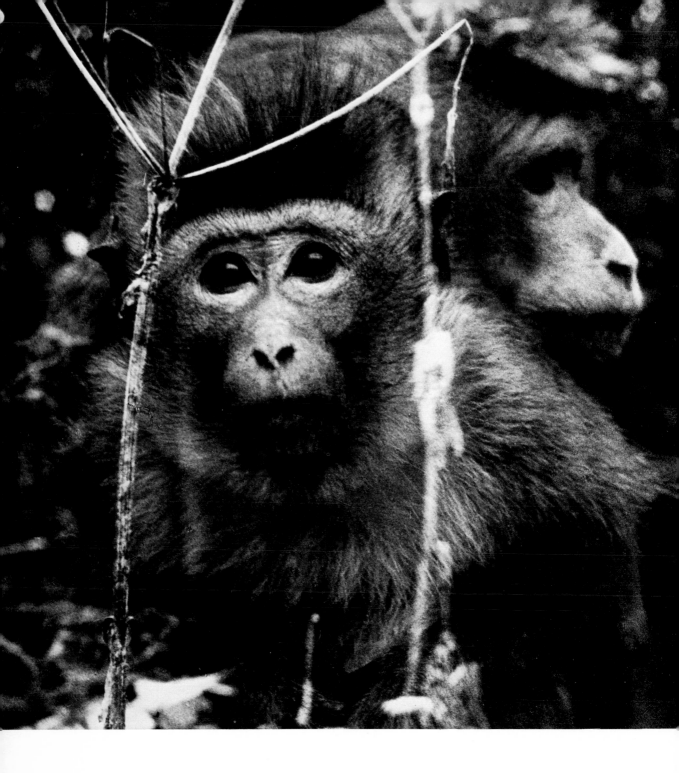

Every creature in Paradise held its breath. "No," whispered the monkeys, "do not pluck the apple."

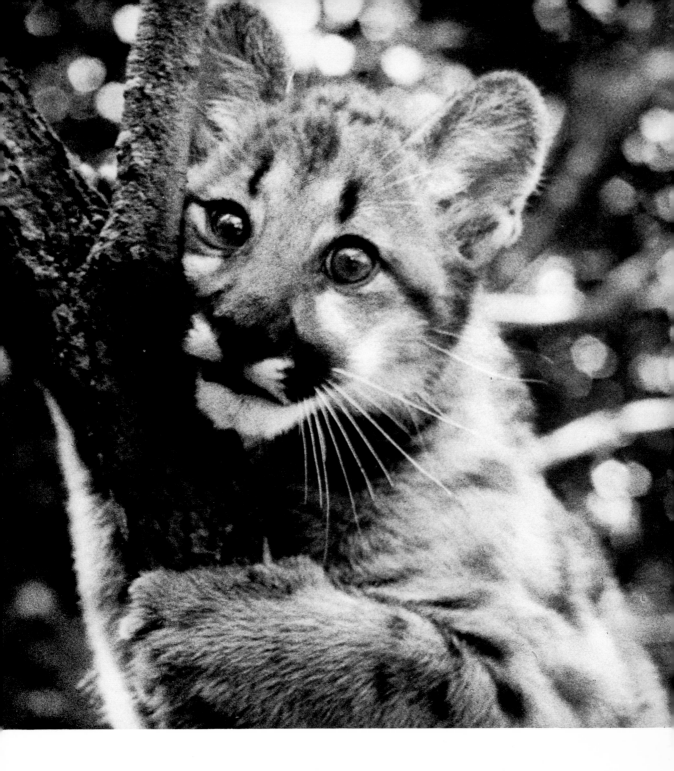

"Leave it, leave it!" they implored.

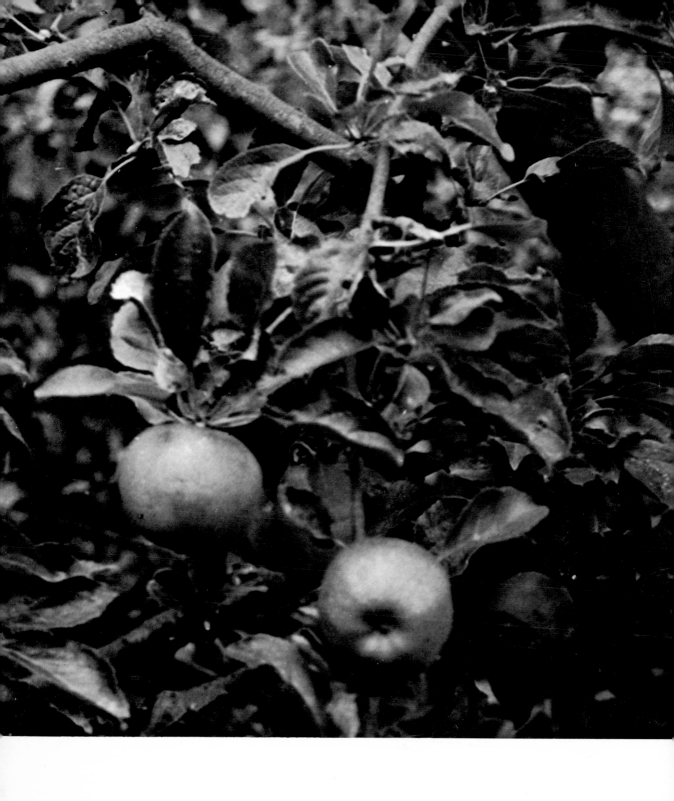

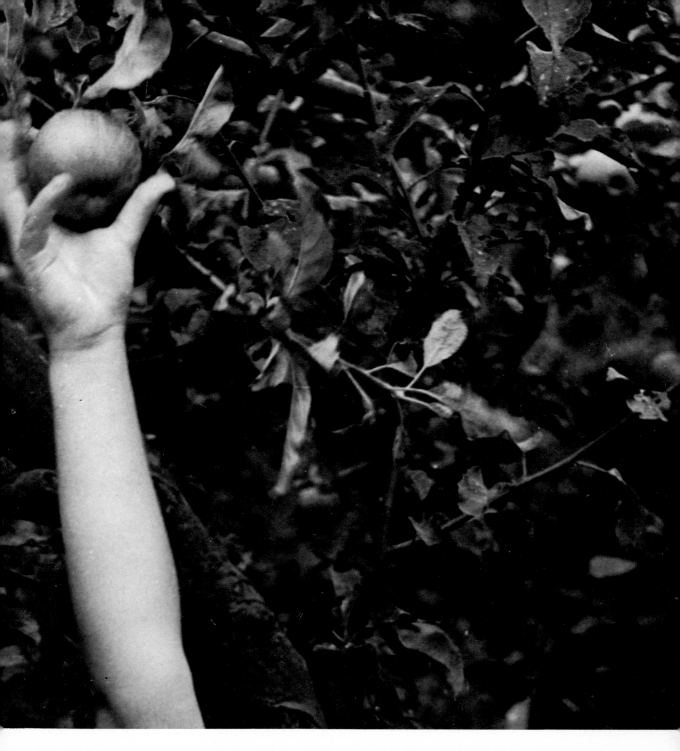

The girl plucked two apples from the tree: one for
herself, one for the boy.
There was nothing I could do to stop them.

When they had eaten the poisoned apples, what I had feared would happen came about.
The sun went down on my paradise.

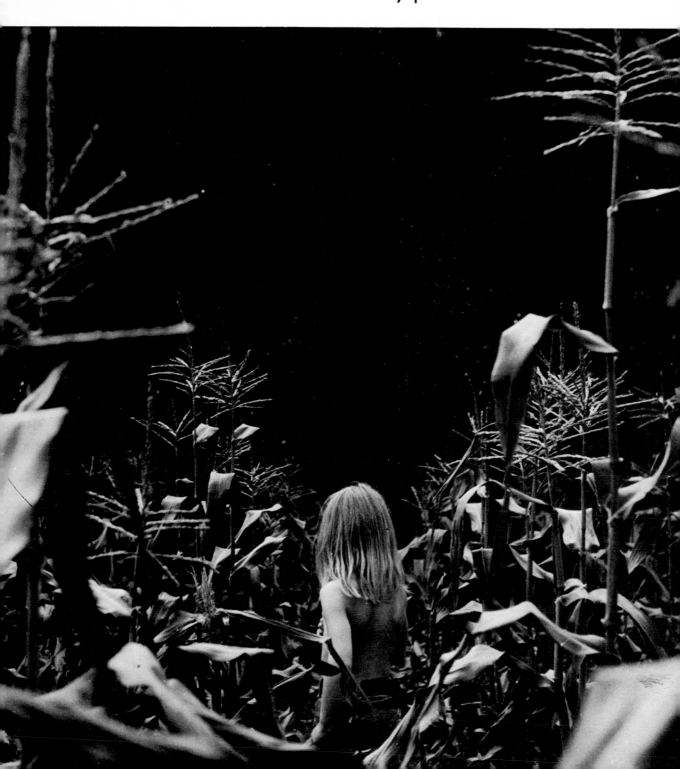

The girl turned aside. She did not want to play.
The boy was troubled.
The joy had gone from Paradise.

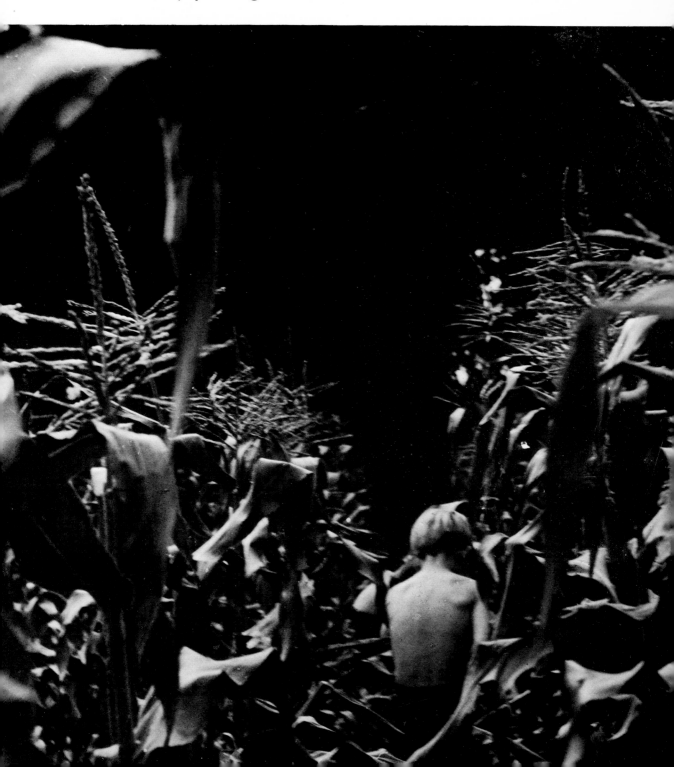

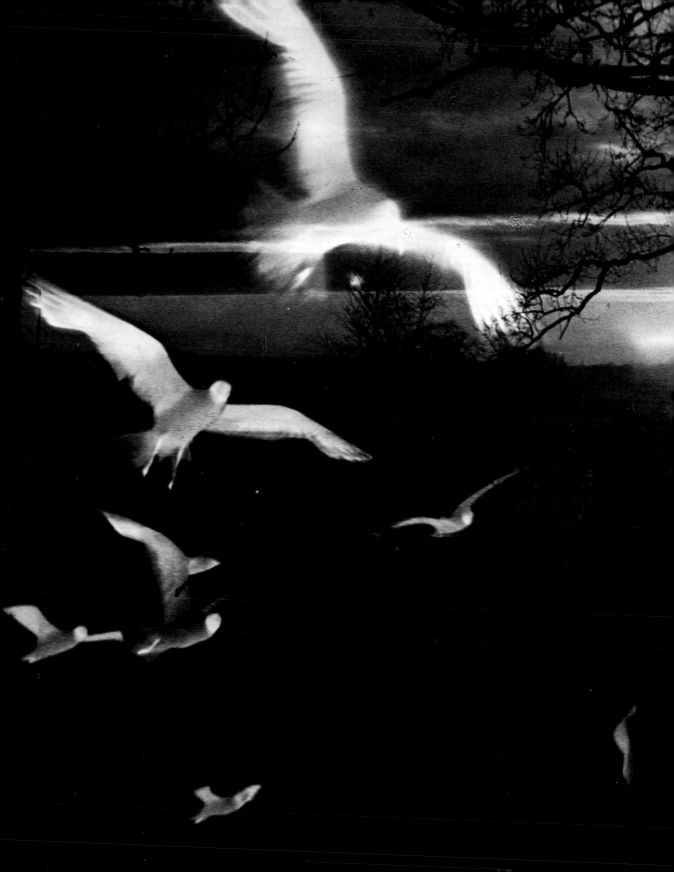

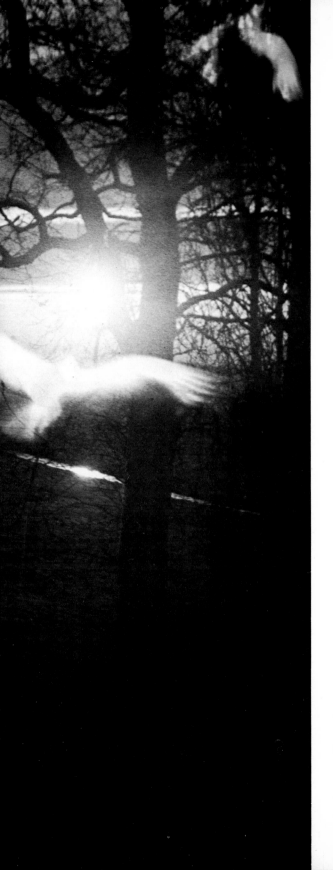

White birds crowded the sky,
shrieking in the darkness.
"Where are you?" the boy
cried to the girl.
"Come to me!"

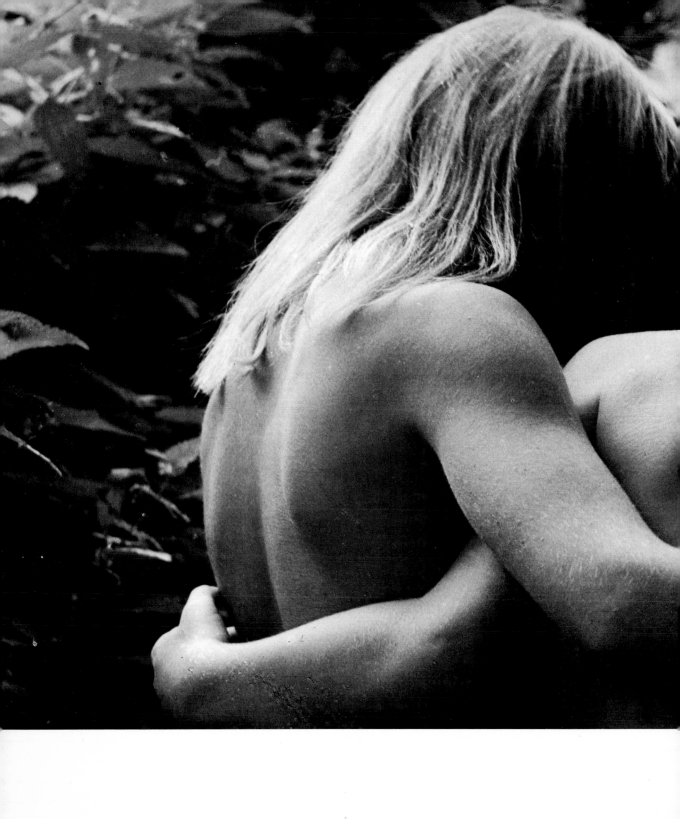

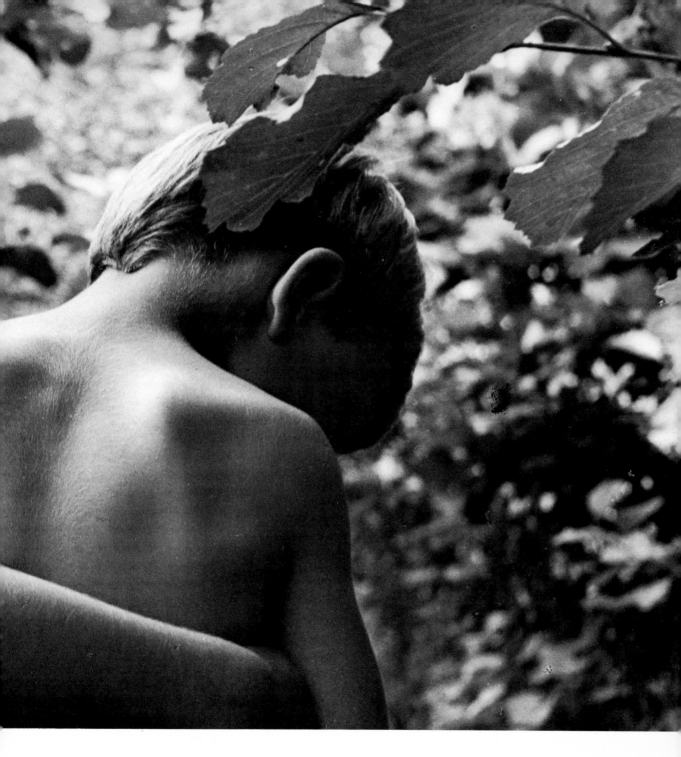

"I am cold and afraid," the boy said.
The girl comforted him. "I am not afraid –
at least, I do not think I am," she told him.

Then I dreamt that I made the sun rise.
"! am not afraid when the sun shines," said the boy.
"Let us walk towards the sun," the girl said. "Then
we need never be frightened."
The boy took the girl's hand and they walked out
of my paradise. I could not stop them going. But
I would let the sun shine on them always.

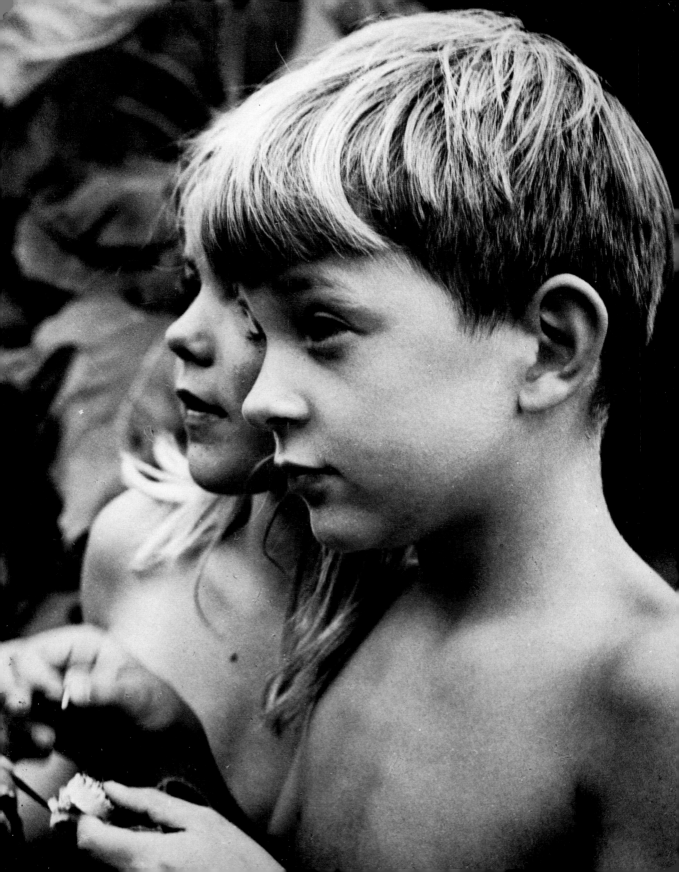